PIRATES, PATRIOTS, AND PRINCESSES

THE ART OF HOWARD PYLE

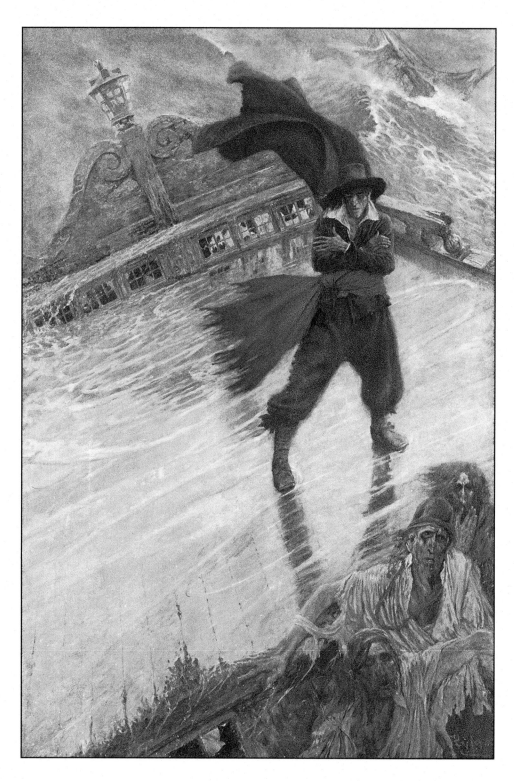

The Flying Dutchman
Collier's Weekly, December 8, 1900

PIRATES, PATRIOTS, AND PRINCESSES

THE ART OF HOWARD PYLE

Selected and Edited by Jeff A. Menges

Yours very sincerely,
Howard Pyle

Dover Publications, Inc., Mineola, New York

Copyright

Copyright © 2006 by Dover Publications, Inc.
Text copyright © 2006 by Jeff A. Menges
All rights reserved.

Bibliographical Note

Pirates, Patriots, and Princesses: The Art of Howard Pyle is a new work, first published by Dover Publications, Inc., in 2006.

Library of Congress Cataloging-in-Publication Data

Pyle, Howard, 1853–1911.
 Pirates, patriots, and princesses : the art of Howard Pyle / selected and edited by Jeff A. Menges.
 p. cm.
 ISBN-13: 978-0-486-44832-9 (pbk.)
 ISBN-10: 0-486-44832-0 (pbk.)
 1. Pyle, Howard, 1853–1911—Themes, motives. I. Menges, Jeff A. II. Title.

NC975.5.P9A4 2006
741.6092—dc22

2006040307

Manufactured in the United States by LSC Communications
44832005 2018
www.doverpublications.com

INTRODUCTION

In Wilmington, Delaware, on the 5th of March in 1853, Howard Pyle was born into a hardworking Quaker family, whose roots could be traced back to the American colonial period. Pyle's family history in the Brandywine Valley had a great impact on how Pyle would later come to view historical events and man's relation with the sea; these two subjects would continually fill his easel with material throughout his career. Reared in the small but busy Eastern city, Howard drew inspiration from his community and the people all around him. His upbringing provided him with a tremendous amount of influences that would remain with him all his life. While growing up, he saw soldiers at an active time of war, and watched as the railroad and shipyard industries flourished. Books were abundant in the Pyle house, and young Howard was immersed in classic tales and stories, which were ingrained into his mind before he was old enough to read them for himself. As a child, Howard found that school and the routine of classwork did not foster the creativity and intelligence that his parents could see in him. Although he was very bright, he had difficulty applying himself to traditional schooling. With an active imagination already beginning to shape his life, the budding young artist spent a good deal of his time in the classroom sketching on his slate.

At the age of sixteen, Pyle had found his calling, and enrolled in a nearby Philadelphia art school, where all his resistance to classwork was replaced with a strong enthusiasm for drawing. After three years of study with a European-trained instructor, he had a good technical foundation, but was dissatisfied with the rigid procedures of imitating. Instead, he sought to create imaginative works similar to the pictures that he remembered fondly from the books of his youth. Bearing this in mind, he realized that his academically trained instructor could be of little further help to him.

At the same time that Pyle was struggling through school, publishing was going through its own extensive changes and growing pains. Industry and mechanization had begun making newspapers and magazines more readily available to the average American, and the American Civil War gave readers a hunger for the latest news, generating an even greater demand for the development of better presses. Photographs were a new technology in picture making, and it would be years before an image of true grayscale tones could be mass-produced (1887). Illustration was the domain of line, and was limited to either black or white. A simple piece of line art, like the pirate above, was carved onto a wooden block and printed with the page's type. When a painting was reproduced, the engraver's role was even more important. It was up to this second craftsman to interpret the illustrator's painting, in effect, rendering the grays in fields of hatched line work. This was the most efficient process at the time for achieving a likeness to a reproduction of a painting, and only the most skilled engravers were employed to work on the best artist's work. Plate 1 within this book is one such engraving, designed and painted by Pyle, and engraved by another. During the 1870s and most of the 1880s, many of Pyle's illustrations would be reproduced in this way, and he began to tailor his work specifically for reproduction by these methods.

Howard Pyle's first success in getting his work in print didn't happen for his artwork alone. It was as an author and illustrator that he sold his first work to *Scribner's Monthly* in the spring of 1876. A few short months later, with a few more published pieces under his belt, a young Howard Pyle went to seek his fame in New York, America's publishing capital. He received work from *Scribner's*, *St. Nicholas*, and *Collier's* as well as a few other periodicals, and began a long-standing relationship with the publishing

house at *Harper's*. Edwin Austin Abbey, A. B. Frost, and Charles Dana Gibson were some of the artists his work would appear with at the end of the nineteenth century. His passion for this work and eagerness to please his clients secured for him a steady income that would place him at the top of his field by the time he was thirty.

At this time in Pyle's career, the need for illustration in publishing was strong and demanding, and the best artists could command very generous pay, drawing attention and fame like a star studio actor from the 1950s, or an elite athlete today. Magazines and book publishers sought to have the finest artists under exclusive contracts, guaranteeing a readership loyal to a given style. Pyle loved the work and the friendships he shared with other artists, but longed for the peace and natural environment that had been his inspiration during his formative years. In 1879, he returned to the Brandywine River Valley near the northern tip of Delaware.

Back in the surroundings where he had spent his youth, he pursued both writing and illustrating. He went on to produce his own versions of tales that he loved as a child, ones that had instantly filled his head with pictures such as *Robin Hood, King Arthur,* and quite a few pirate tales. A good deal of Pyle's future output would be devoted to the children's market. With the success of his books, Pyle was now in great demand as an illustrator, and his work at this time often centered on historical subjects, a theme in which he so excelled.

The course he was about to take in the Brandywine Valley would cultivate a legacy that has had a profound impact on succeeding generations of illustrators. In 1894, at the age of forty-one, Pyle began teaching courses at the Drexel Institute in Philadelphia. With his published work, he had already made a tremendous mark in a growing field that would always trace its roots back to him, but it was his years as a teacher, and the lasting impression he left on a generation of illustrators that would cause him to be known today as the "Father of American Illustration." His teaching at Drexel boosted his reputation quickly, and before long he was teaching two days a week in addition to fulfilling his illustration work-load. His techniques focused on practical application and reflected current trends in artistic direction, making his lessons very appealing to students.

After some summer studies experiments with students from Drexel in 1898 and 1899, he left this position to open his own private school at Chadds Ford, Pennsylvania, in 1900. Pyle's students at Chadds Ford lived at the school and worked in studios that Pyle had built. The workday was long, six days a week, and intense. It was, in fact, an early artist colony, with Pyle providing its direction. The number of students he took in was small by comparison to other schools, but as the sole force behind the program, his attention to each student and the room-and-board requirement meant keeping the class to a small yet manageable size. His ability to recognize the right components for success in a prospective student was remarkable. Pyle's reputation drew students from great distances, and many of those who studied under him, both at Drexel and at Chadds Ford, would go on to become major players in illustration. The list is impressive: Violet Oakley, Jessie Willcox Smith, and Elizabeth Shippen Green would ultimately become

some of the strongest women illustrators in the first half of the twentieth century. Frank Schoonover, Stanley Arthurs, and Harvey Dunn all found areas of specialty and commercial success. Dunn would also go on to become an important teacher to the next generation of illustrators. When Maxfield Parrish came to Pyle for instruction, Pyle urged him to get to work, telling him that he already possessed what was needed to succeed. In late 1902, Pyle met a student that would become his most successful pupil, Newell Convers Wyeth. Wyeth was twenty years old when he began to study under Howard Pyle, and he eventually became one of the premier illustrators in America, from the time of his landmark *Treasure Island* in 1911 until his untimely death in 1945.

In 1905, after the students that most interested him were established in professional careers (and with mounting doubts about his own work in a field swelling in numbers), Pyle thought it was time to dissolve the school. For Pyle, there may also have been some distaste for the direction that illustration appeared to be moving toward that brought him to a decision few might have predicted. In 1906 he accepted a position as art editor for *McClure's Magazine*. Perhaps it was with the ambition of compiling the type of magazine he had hoped would prevail in publishing's future. He was to work in New York three days a week, allowing him time for his own work. It was a strained arrangement from the start, as the magazine required more direct attention and involvement from him, and this setup did not last more than a few months.

Pyle's last foray into artistic expression was with mural painting. He had executed a work for the Minnesota State Capitol, titled "The Battle of Nashville" (Plate 26) in 1906. Two more commissions for murals followed shortly thereafter, both for New Jersey Courthouses, in Essex and Hudson Counties. Murals presented new challenges for Pyle—the scale, differences in lighting, and varying points of view—all of which required a different solution than a piece for a magazine or book illustration. Looking for answers to these questions, Pyle began to think that viewing the work of the old masters in Italy might show him how to progress with his future large-scale works. At a time when his finances were less certain, and living in Italy was an inexpensive alternative, Pyle and his family took leave of Wilmington, planning to be abroad for only a year. After leaving New York in November of 1910, Pyle's health faltered in Italy and took a downturn the following autumn. He died in Italy on November 9, 1911, leaving his indelible mark on publishing, illustration, and art instruction for the better part of the next century and well into the twenty-first.

Jeff A. Menges
February 2006

The North Wind flies with y̌ faithful Servant.

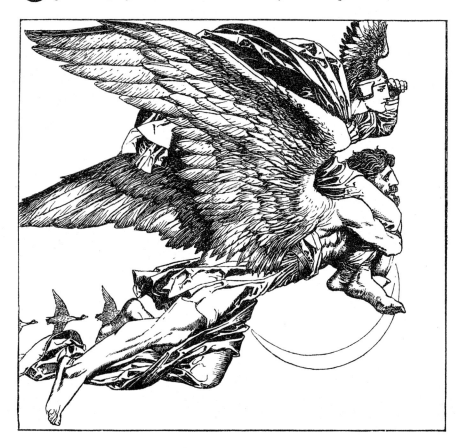

DEDICATION

To Dennis Fritz, who told me to go to the third floor library and look up
the Brandywine School, among other things.

ACKNOWLEDGMENTS

to a group of supporters whose involvement genuinely
helped this project become reality

Joel Keener

Barbara Nessim

Bud Plant

Walt Reed and Fred Taraba of Illustration House

R. Wayt Smith

and

The Dover Staff, especially John Grafton and Susan Rattiner—

List of Plates

THE PLATES

Pirates"

Pirates, privateers, and sailors of all sorts—
Pyle loved adventures at sea and the char-
acters who lived these exciting escapades.
Whether he depicted the finery of a French
captain or the layered filth of a starving
mutineer, Pyle reveled in the treatment
of the subject. In and around his native
Wilmington, Pyle was familiar with the
towering masts of clipper ships and the
like, and had opportunities to investigate
the proper positioning of a sail or the work-
ings of rigging, even as the age of sail was
drawing to a close. He gravitated toward
scenes of seafarers more than any other
subject, completing over fifty paintings and
countless black and white illustrations with
maritime themes.

Howard Pyle's Book of Pirates was published
posthumously in 1921, compiling a varied
selection of Pyle's original writing on the
subject with some of his finest illustrations.
This book remains in print today, and has
become a definitive source on how pirates
were depicted both in art and literature.

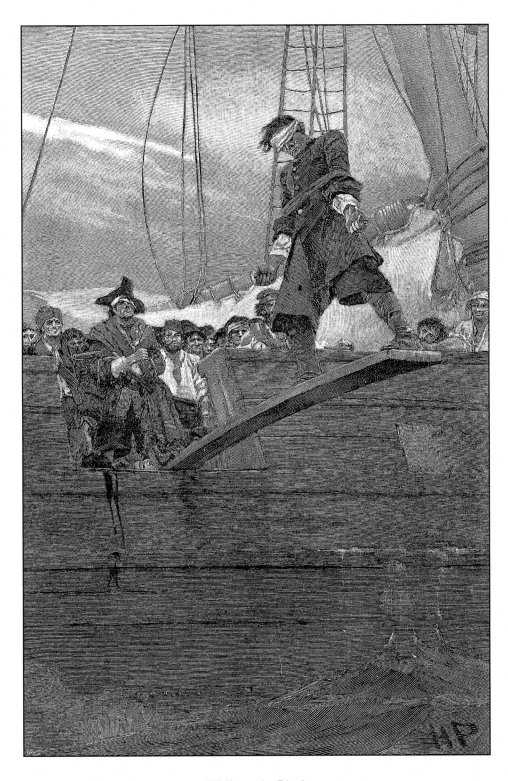

Walking the Plank
BUCCANEERS AND MAROONERS OF THE SPANISH MAIN
Harper's New Monthly Magazine, September 1887

Plate 1

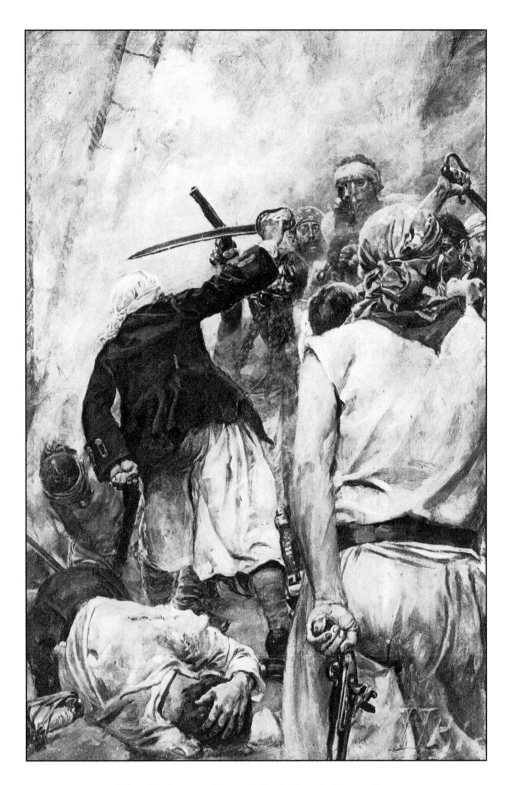

The Combatants Cut and Slashed with Savage Fury
a.k.a. Blackbeard's Last Fight
JACK BALLISTER'S FORTUNES
The Century, 1894

Plate 2

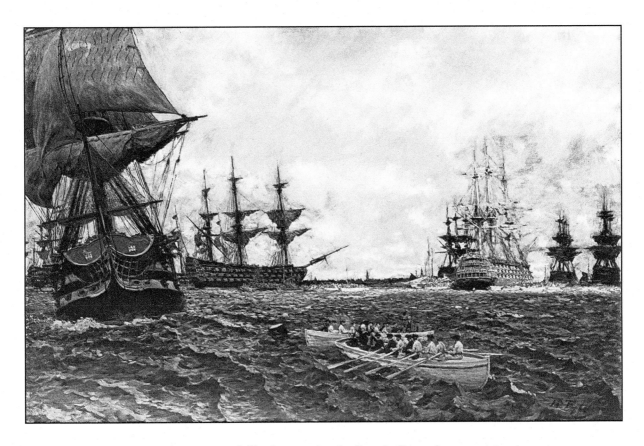

The Evacuation of Charlestown by the British, December 14, 1782
THE STORY OF THE REVOLUTION
Scribner's Magazine, September 1898

Plate 3

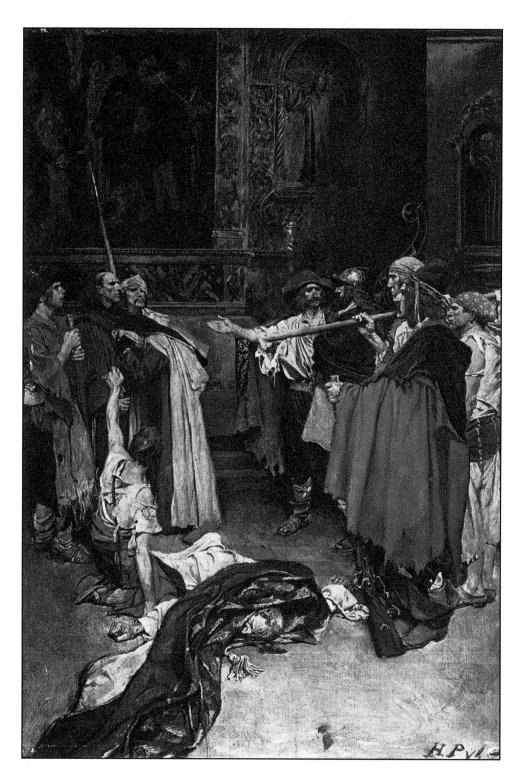

On the Edge of the Ring, Guarded, Stood
Brother Bartholome and the Carmelite
Poisoned Ice
Collier's Weekly, December 17, 1898

Plate 4

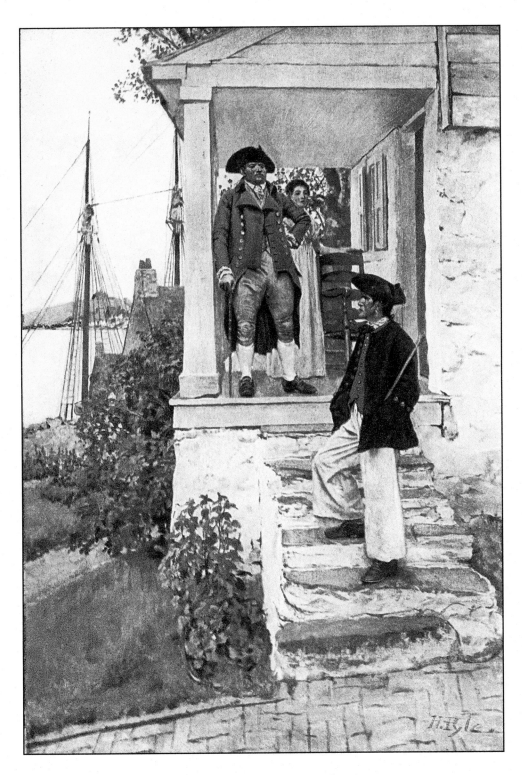

And You Shall Not Hinder Me
THE OLD CAPTAIN
Harper's Monthly, December 1898

Plate 5

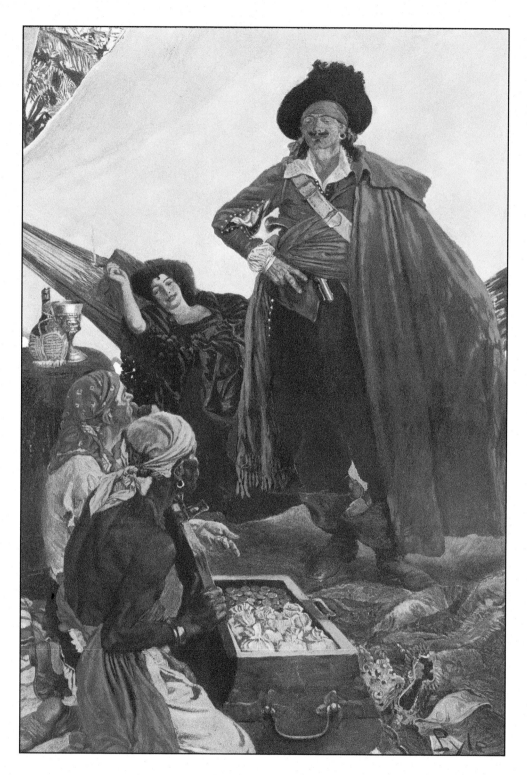

How the Buccaneers Kept Christmas
Harper's Weekly, December 16, 1899
A double page in color

Plate 6

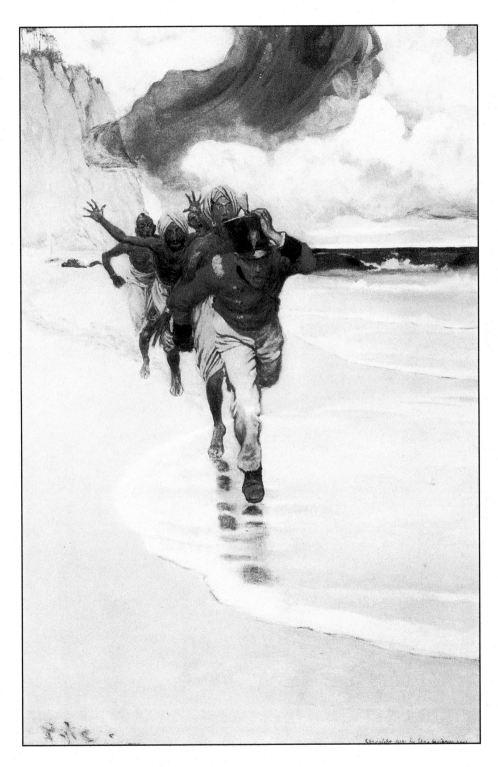

We Started to Run Back to the Raft for Our Lives
SINBAD ON BURRATOR
Scribner's Magazine, August 1902

Plate 7

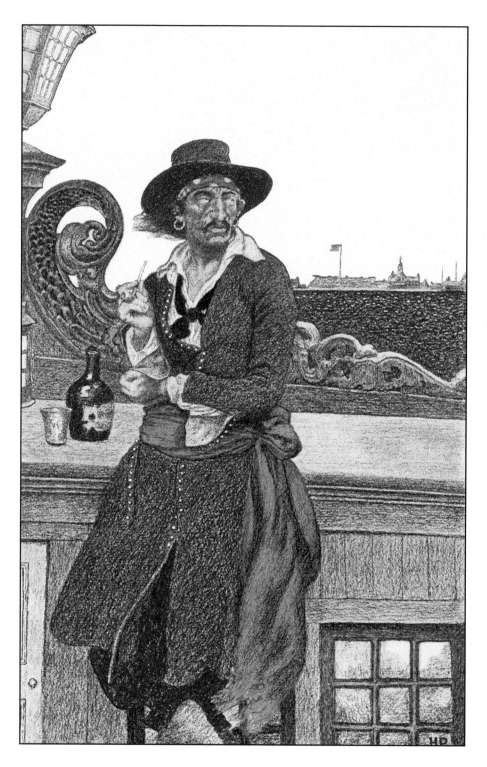

Kidd on the Deck of the "Adventure Galley"
THE TRUE CAPTAIN KIDD
Harper's Monthly, December 1902

Plate 8

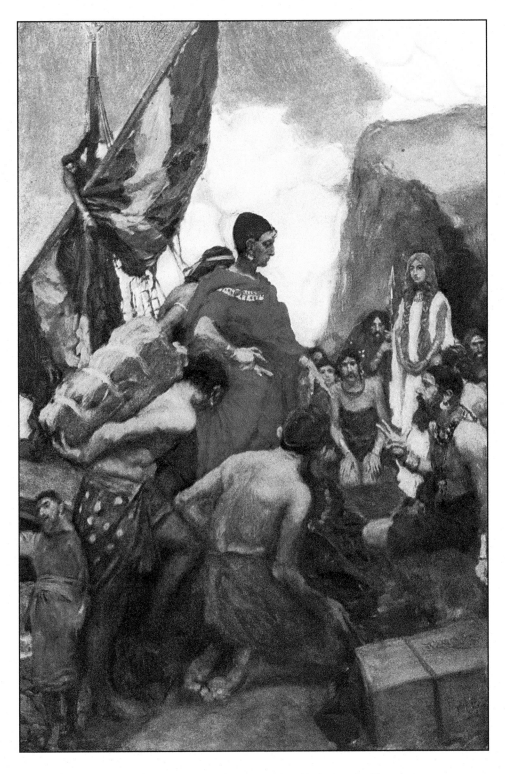

The Dark Folk Trooped to Meet Them on the Shore
THE SWORD OF AHAB
Harper's Monthly, August 1904

Plate 9

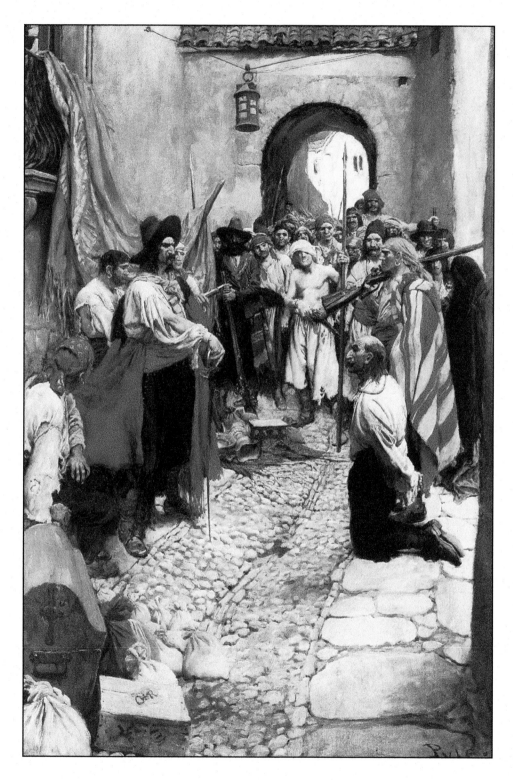

Extorting Tribute from the Citizens
THE FATE OF A TREASURE TOWN
Harper's Monthly, December 1905

Plate 10

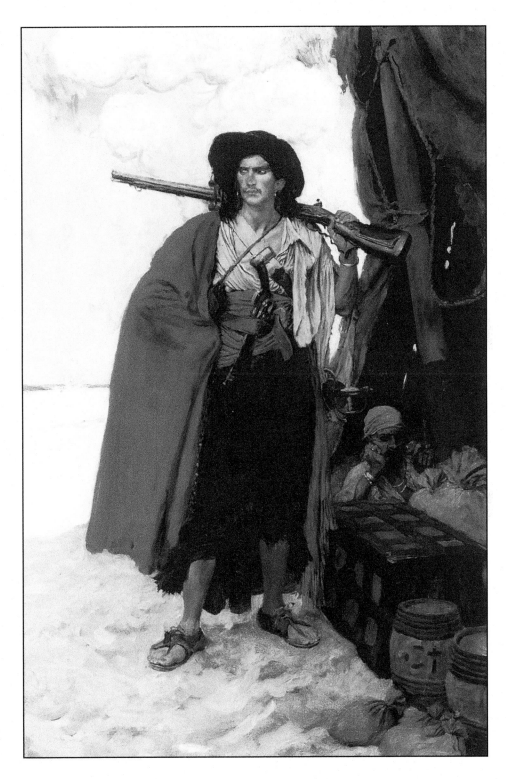

The Buccaneer Was a Picturesque Fellow
THE FATE OF A TREASURE TOWN
Harper's Monthly, December 1905

Plate 11

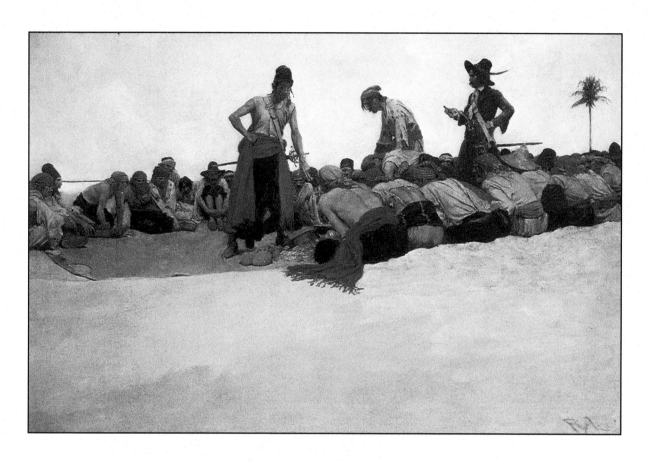

So the Treasure Was Divided
THE FATE OF A TREASURE TOWN
Harper's Monthly, December 1905

Plate 12

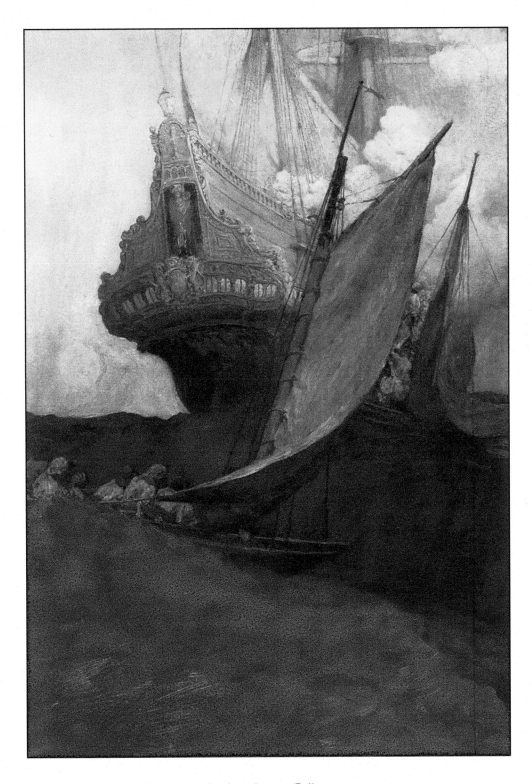

An Attack on a Galleon
THE FATE OF A TREASURE TOWN
Harper's Monthly, December 1905

Plate 13

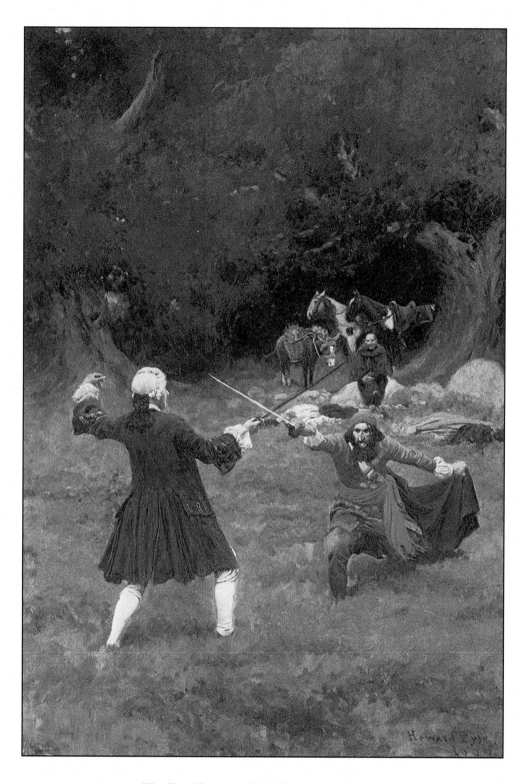

The Duel Between John Blumer and Cazaio
IN THE SECOND APRIL
Harper's Monthly, April 1907

Plate 14

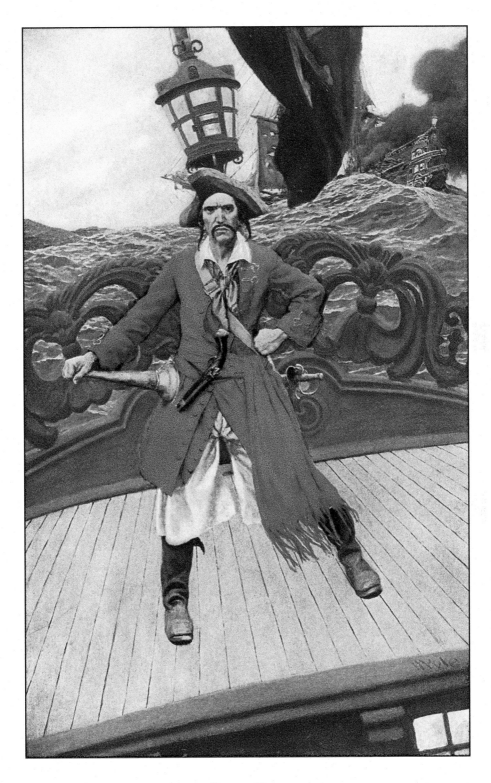

Captain Keitt
THE RUBY OF KISHMOOR
Harper's Monthly, August 1907

Plate 15

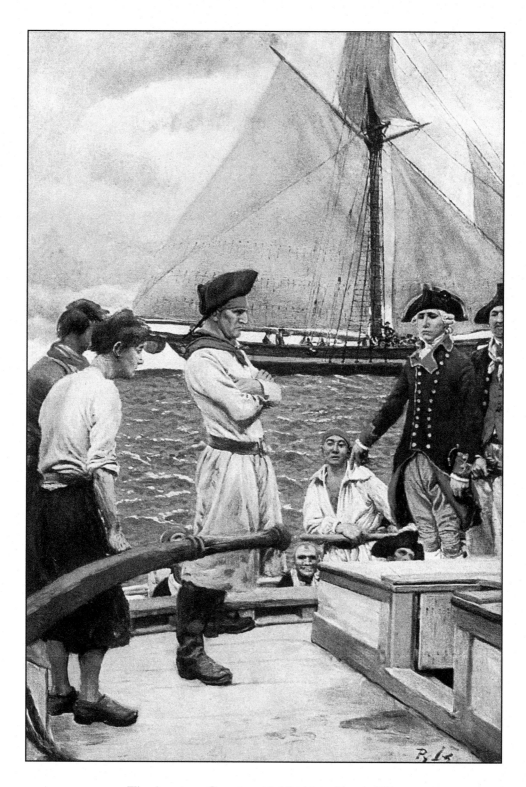

The American Captain with His Mate Boarded Us
PENNSYLVANIA'S DEFIANCE OF THE UNITED STATES
Harper's New Monthly Magazine, October 1908

Plate 16

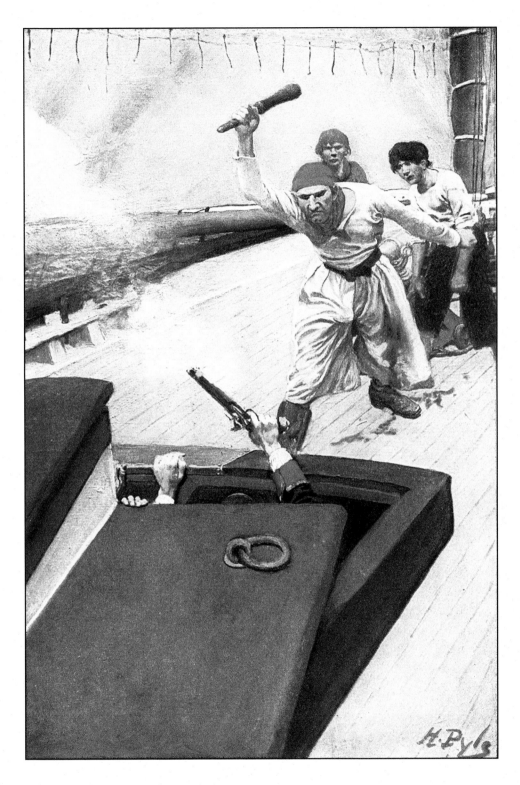

Then the Real Fight Began
PENNSYLVANIA'S DEFIANCE OF THE UNITED STATES
Harper's New Monthly Magazine, October 1908

Plate 17

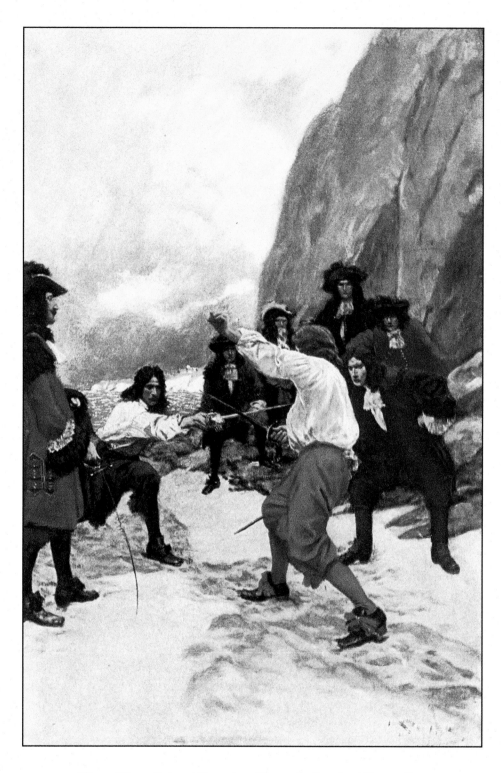

Theirs Was a Spirited Encounter Upon the Beach of Teviot Bay
THE SECOND CHANCE
Harper's Monthly, October 1909

Plate 18

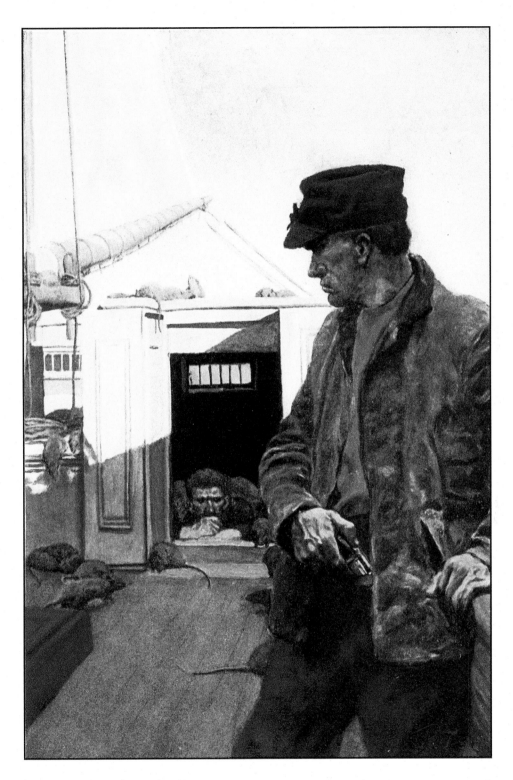

He Watched Me As a Cat Watches a Mouse
THE GRAIN SHIP
Harper's Monthly, November 1909

Plate 19

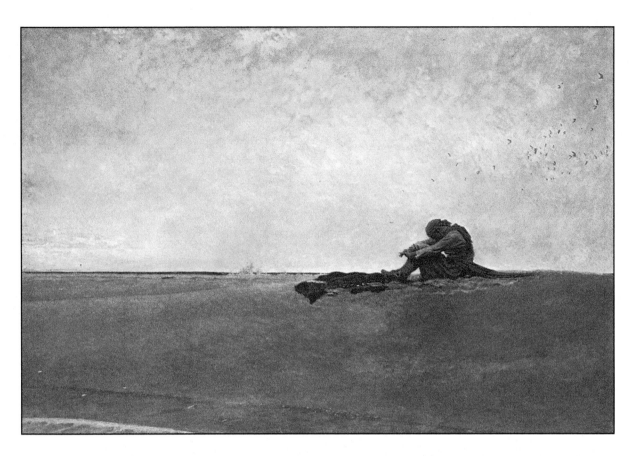

Marooned
Unpublished, 1909

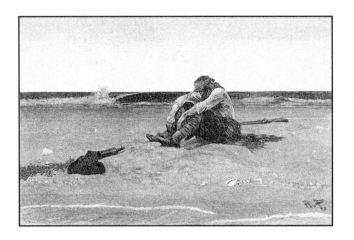

Done after a subject originally for
BUCCANEERS AND MAROONERS OF THE SPANISH MAIN
Harper's New Monthly Magazine, September 1887

Plate 20

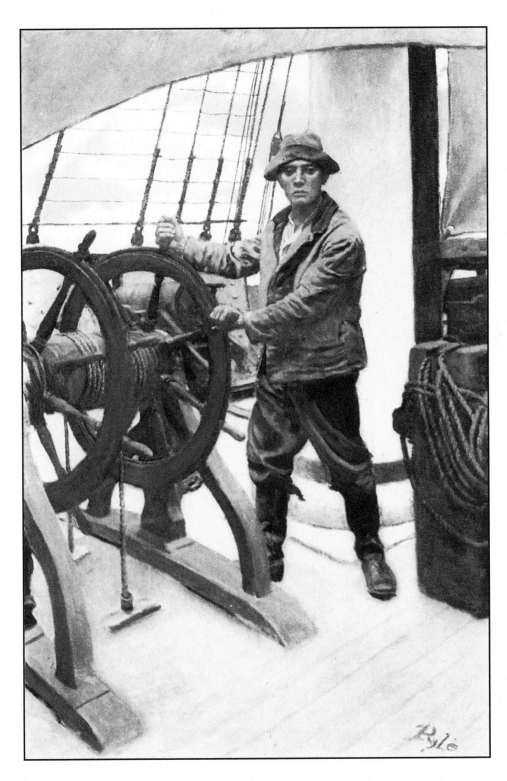

Page Was at the Wheel, Steering
"PAGE, A.B."
Harper's Monthly Magazine, July 1910

Plate 21

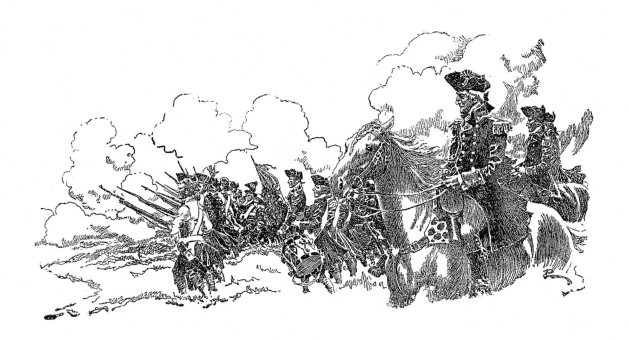

Patriots

Patriots exist in every country, be they colonials, soldiers, or explorers. These individuals have dedicated themselves to supporting a greater good, either through their politics or their mighty saber. While some seek to make their claims through discovery, others do so by conquest. The following plates depict loyal patriots who bear a fervent passion for their country, regardless of the hardships they may have had to endure along the way.

As an American who grew up in an area steeped in the early history of his nation, Pyle had an especially keen interest in the American Revolution. These historical pieces exhibit an unusual attention to detail, and obviously required extensive research in clothing, hair, weaponry, and even footwear. In fact, it was not unheard of for him to travel to actual sites when working from history, or to dress his students and neighbors in period uniforms for reference.

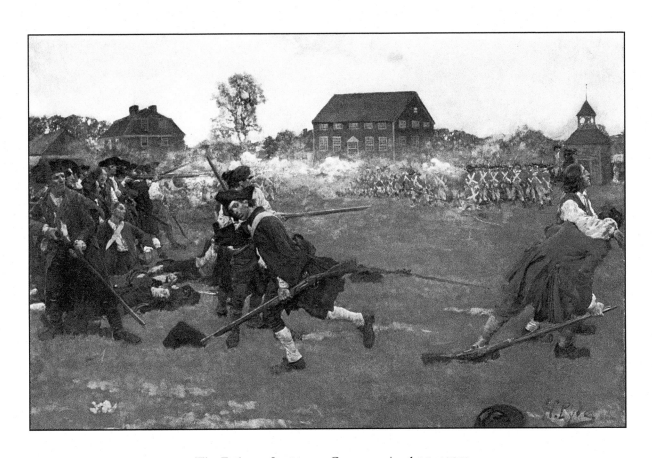

The Fight on Lexington Common. April 19, 1775
THE STORY OF THE REVOLUTION
Scribner's, January 1898

Plate 22

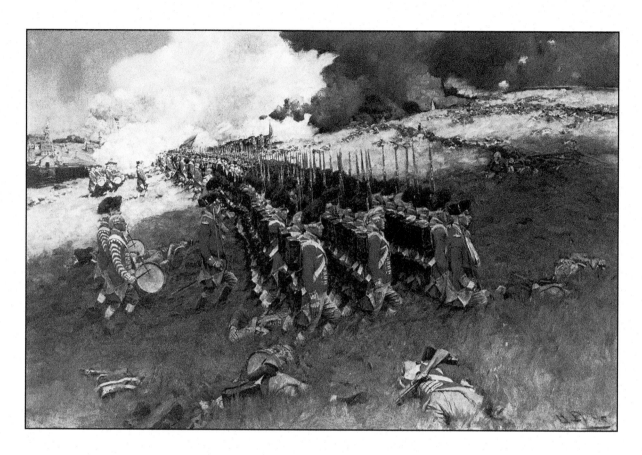

The Battle of Bunker Hill
THE STORY OF THE REVOLUTION
Scribner's, February 1898

Plate 23

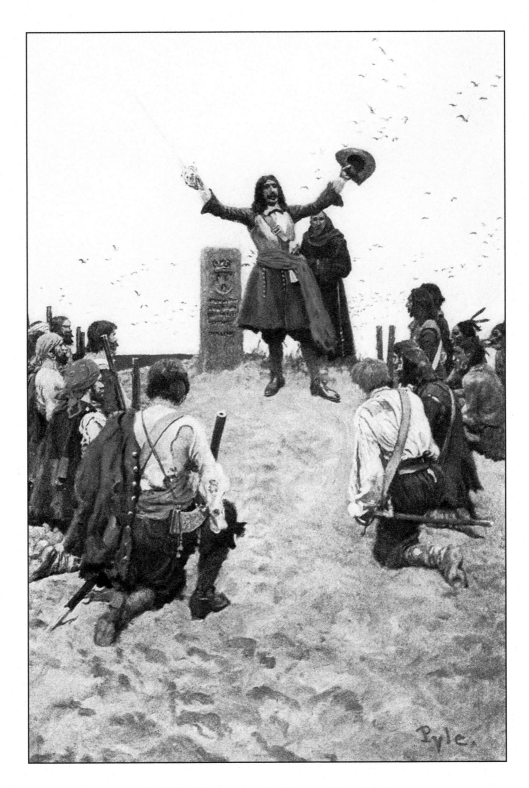

La Salle Christening the Country "Louisiana"
THE GREAT LA SALLE
Harper's Monthly, February 1905

Plate 24

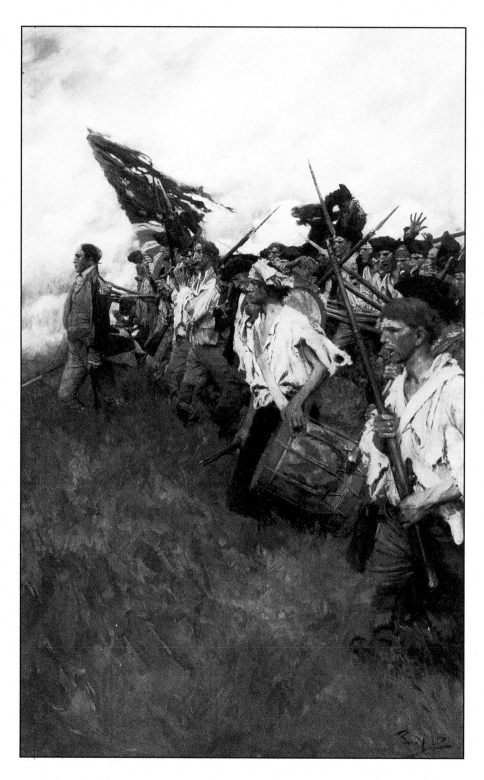

The Nation Makers
Collier's Weekly, June 2, 1906
Originally done in 1903

Plate 25

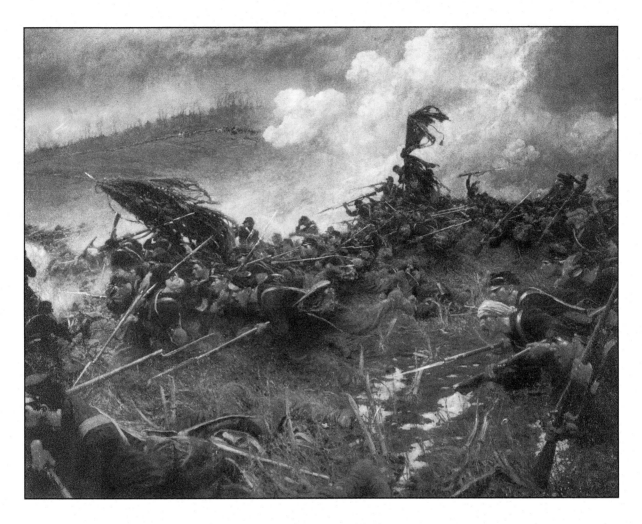

The Battle of Nashville
Mural, State Capitol, Saint Paul, Minnesota
1906

Plate 26

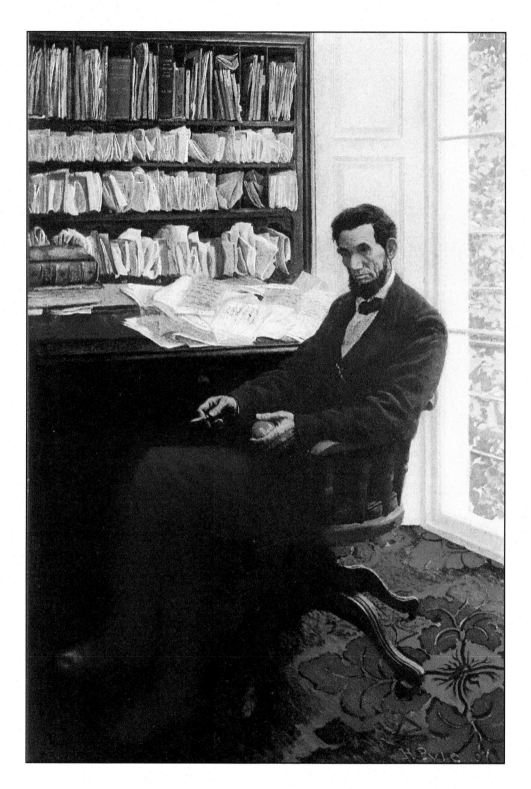

Abraham Lincoln
LINCOLN'S LAST DAYS
September 1907

Plate 27

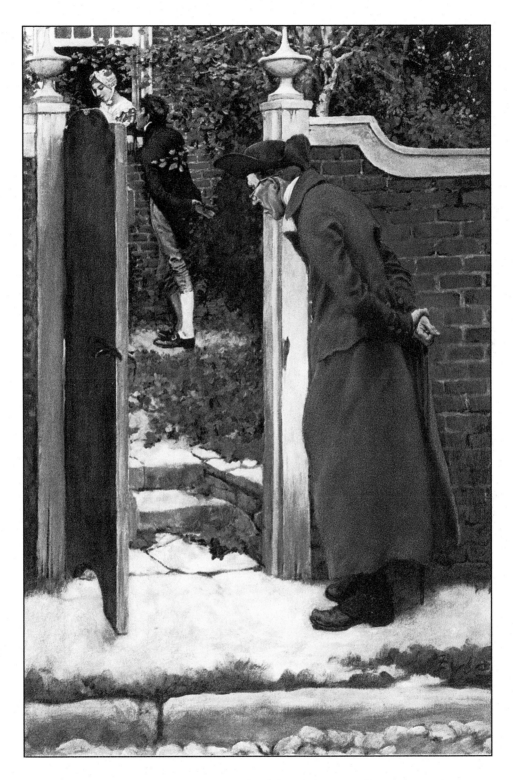

Old Jacob Van Kleek Had Never Favored Our Hero's Suit
THE MYSTERIOUS CHEST
Harper's Monthly, December 1908

Plate 28

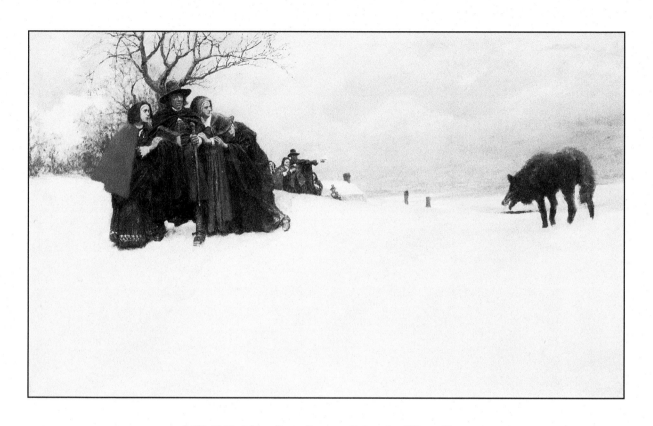

A Wolf Had Not Been Seen at Salem for Thirty Years
THE SALEM WOLF
Harper's Monthly, December 1909

Plate 29

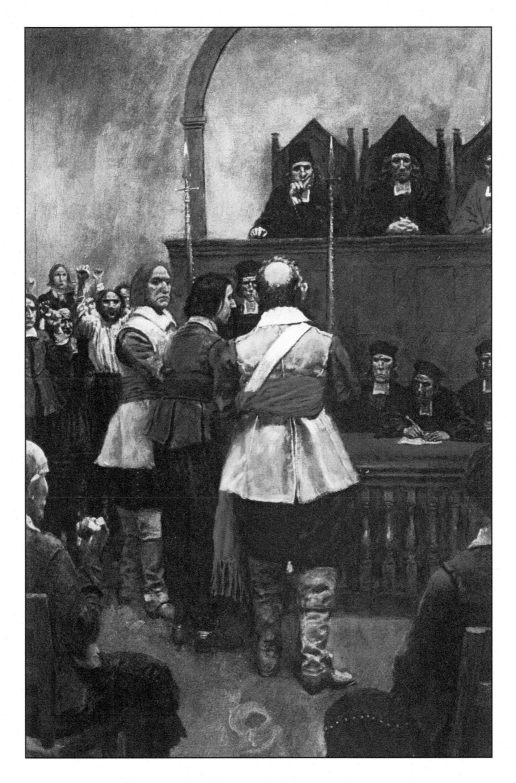

They Questioned Him with Malevolent Persistence
THE BLACK NIGHT
Harper's Monthly, June 1910

Plate 30

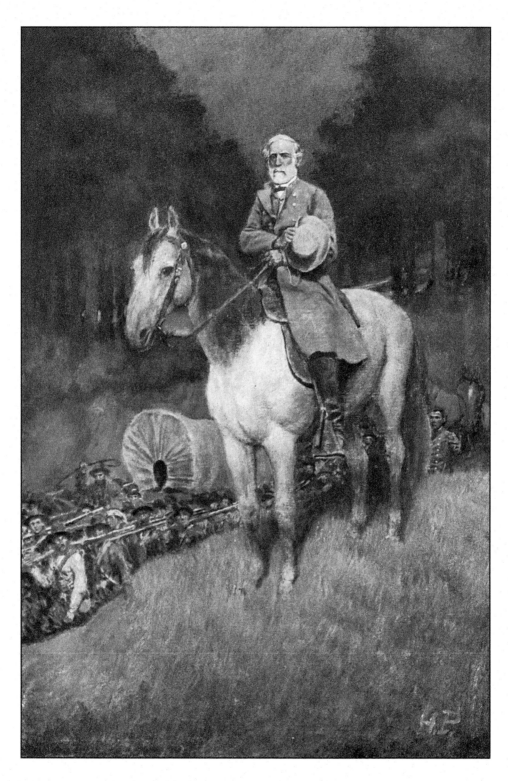

General Lee on His Famous Charger "Traveller"
GENERAL LEE AS I KNEW HIM
Harper's New Monthly Magazine, February 1911

Plate 31

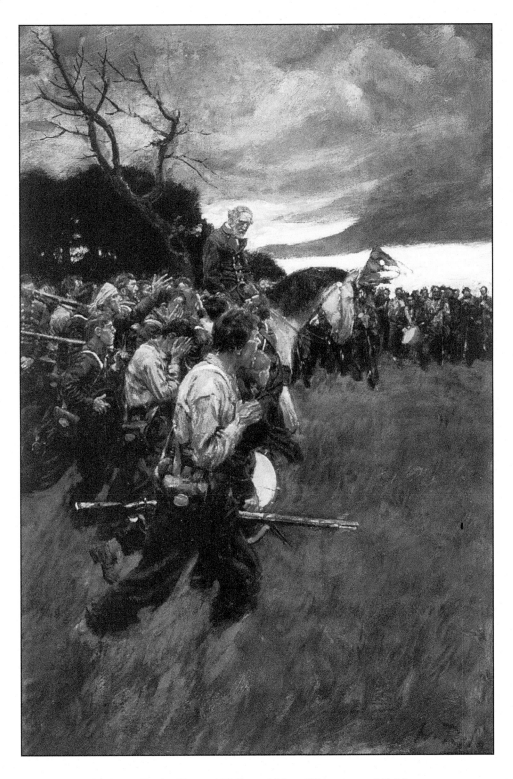

His Army Broke Up and Followed Him, Weeping and Sobbing
GENERAL LEE AS I KNEW HIM
Harper's New Monthly Magazine, February 1911

Plate 32

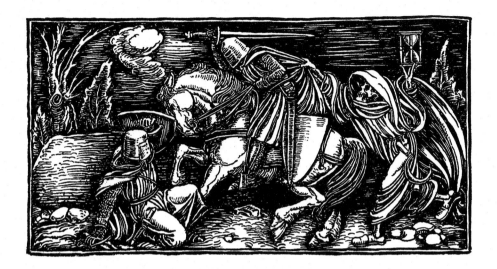

Paladins

At the turn of the century, a renewed interest in tales of chivalry became fashionable for literary entertainment. Perhaps some of this was inspired by generations of Pyle's readers growing older; the success of his own books—*Robin Hood, Otto of the Silver Hand*, and the King Arthur set—certainly were affected by the public's taste for castles and jousts.

Authors such as James Branch Cabell and James Baldwin created some new stories and reworked other tales of mercenary knights, dark princes, and fair maidens. Pyle's dutiful attention to historic detail and his admiration for contemporary works of artists such as Dürer and Holbein brought believability to his depictions of the period, keeping him a public favorite in this genre for most of his career.

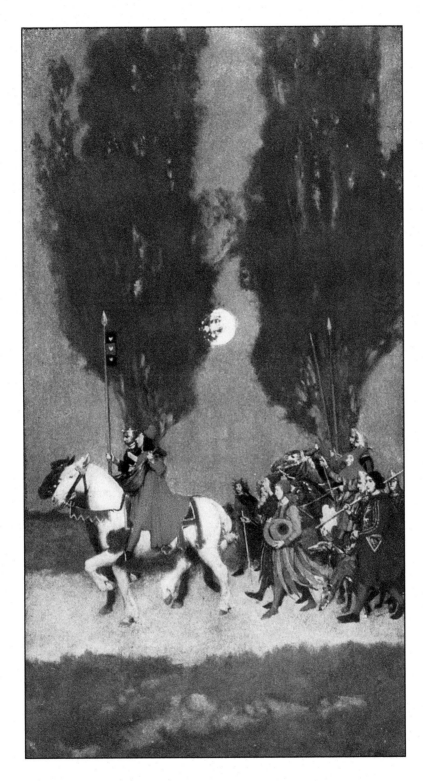

In the Train of King Alfonso
PEIRE VIDAL, TROUBADOUR
Harper's Monthly, December 1903

Plate 33

At the Gate of the Castle
PEIRE VIDAL, TROUBADOUR
Harper's Monthly, December 1903

Plate 34

Her Whisper Was So Soft He Only Guessed the Words
THE STAIRWAY OF HONOR
Harper's Monthly, January 1904

Plate 35

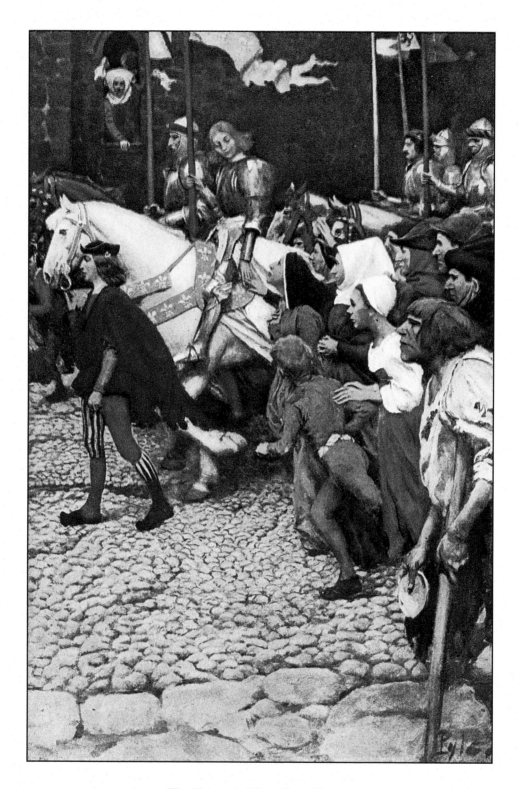

The Triumphal Entry Into Rheims
ST. JOAN OF ARC
Harper's Monthly, December 1904

Plate 36

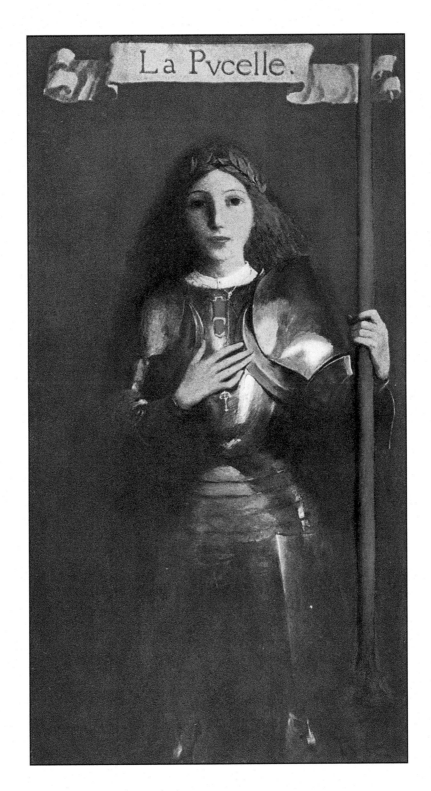

A Lithe, Young, Slender Figure
St. Joan of Arc
Harper's Monthly, December 1904

Plate 37

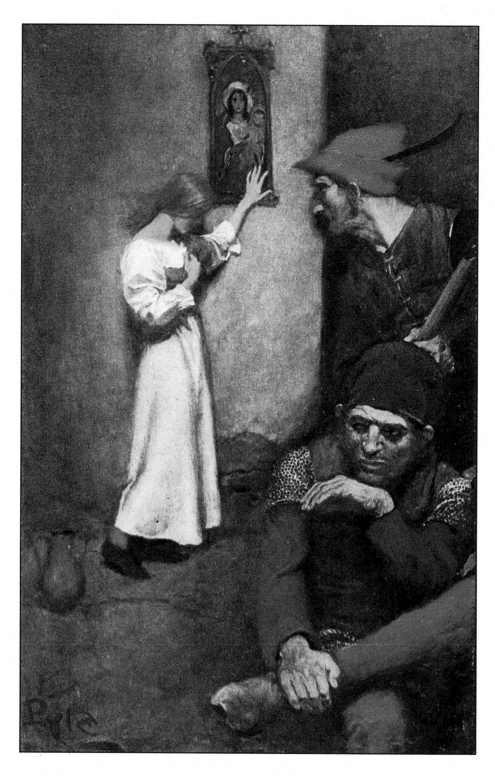

Guarded by Rough English Soldiers
ST. JOAN OF ARC
Harper's Monthly, December 1904

Plate 38

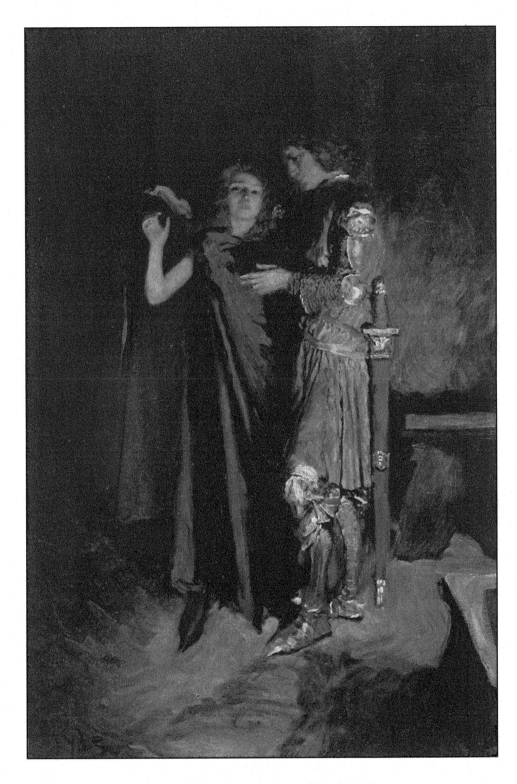

He Laid the Mantle Over the Girl's Shoulders
THE ISLAND OF ENCHANTMENT
Harper's Monthly, Part I, September 1905

Plate 39

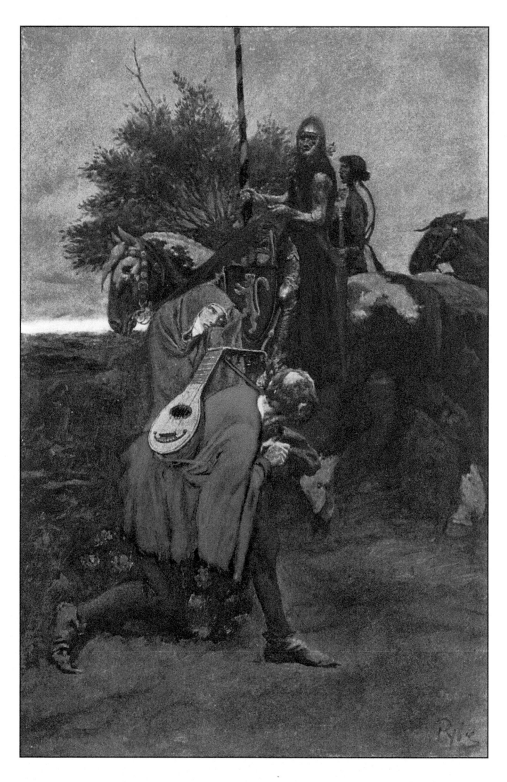

They Were Overtaken by Falmouth Himself
THE SESTINA
Harper's Monthly, January 1906

Plate 40

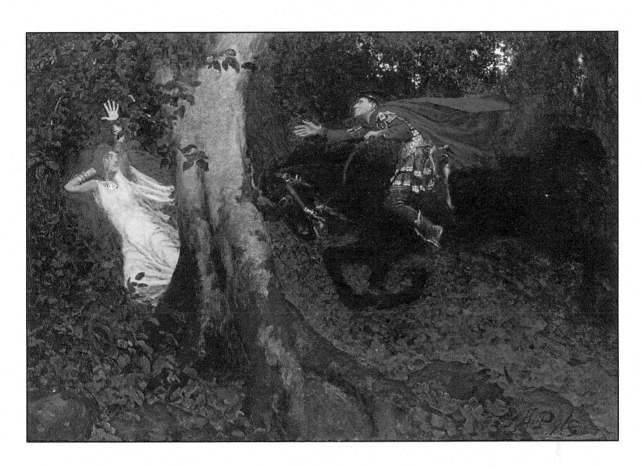

Horse and Man Plunged Heavily After Her
A PRINCESS OF KENT
Harper's Monthly, April 1908

Plate 41

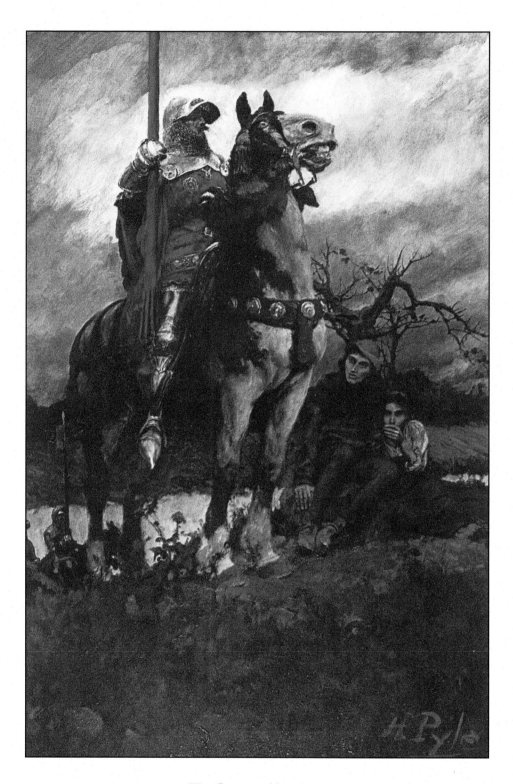

The Coming of Lancaster
THE SCABBARD
Harper's Monthly, May 1908

Plate 42

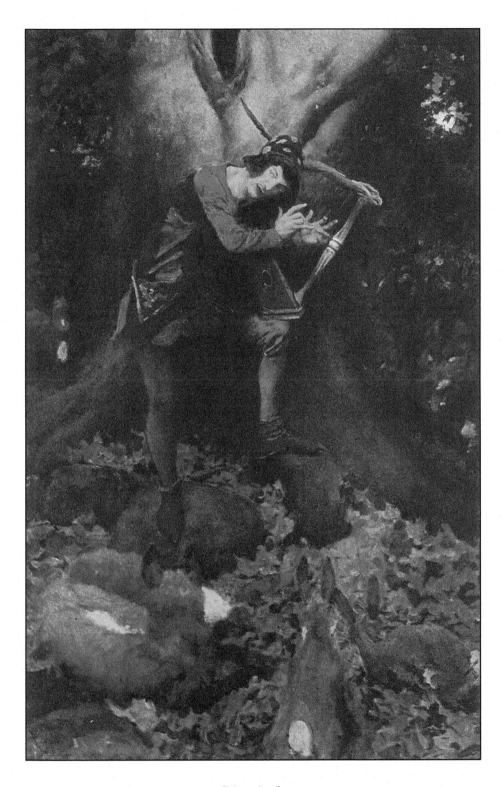

Edric the Singer
EDRIC AND SYLVAINE
Harper's Monthly, August 1908

Plate 43

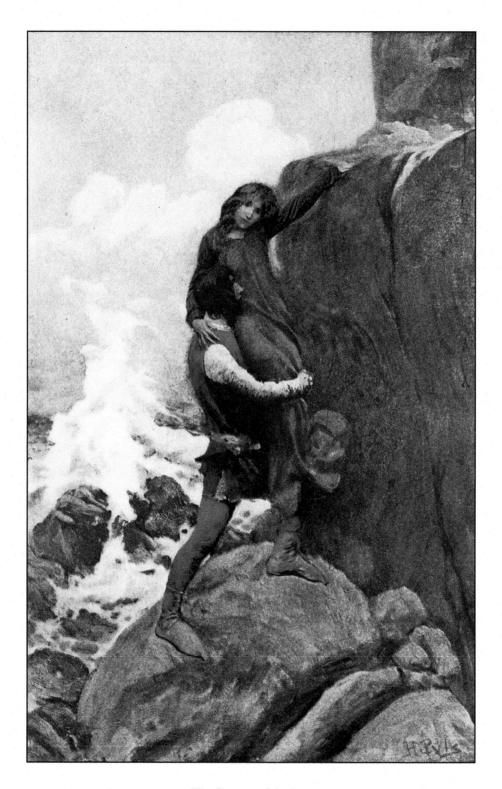

The Rescue of Azilicz
THE MAID OF LANDEVENNEC
Harper's Monthly, September 1909

Plate 44

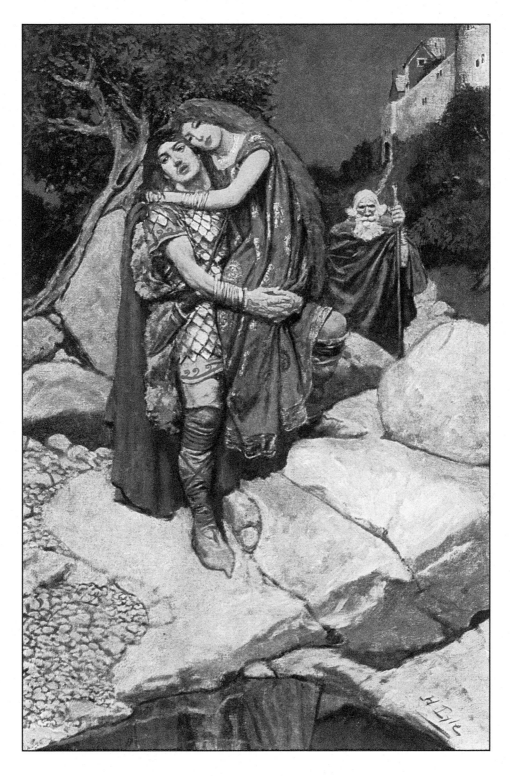

Thereafter She Clung Close About Randver
SWANHILD
Harper's Monthly, January 1910

Plate 45

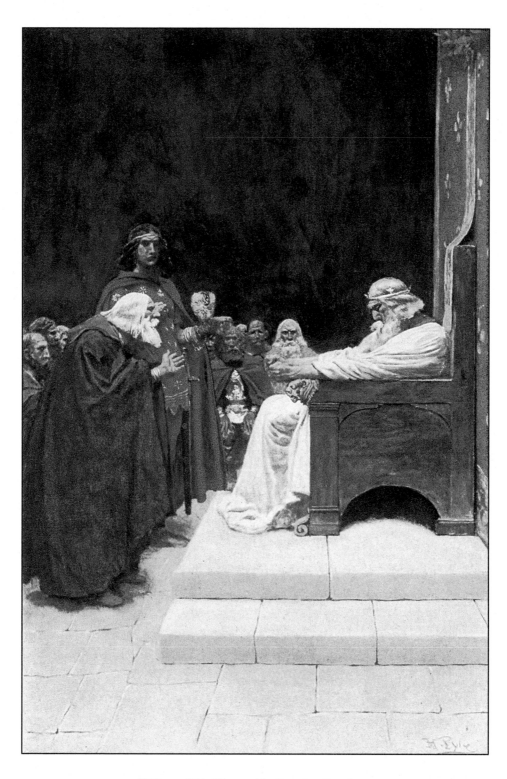

"I Grow Old, Having No Son But Randver"
SWANHILD
Harper's Monthly, January 1910

Plate 46

Flaggingly the Reed Pen Went Up and Down the Vellum
INITIAL LETTER
Harper's Monthly, April 1910

Plate 47

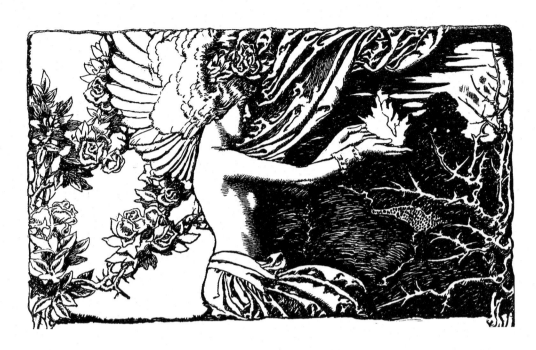

Parable & Myth

Pyle was a spiritual man. Born into a family with deep-seated Quaker beliefs, Pyle's work ethic commanded both his own habits and that of his students. Like the history he was so fond of, he enjoyed exploring the ideas of ancestral beliefs as well as religious beliefs, ancient gods, spirits, ghosts, and mythology.

The Pilgrimage of Truth was a series of pieces that Pyle had envisioned after a long bike ride back from Wilmington. In the story, the character of Truth sought the right temper of companion and found it best in the fool. It was common for Pyle to fall into introspective moods, something that his students learned to respect. In *The Travels of the Soul*, Pyle put together four illustrations with a similar type of short tale, all about the journey through one's life.

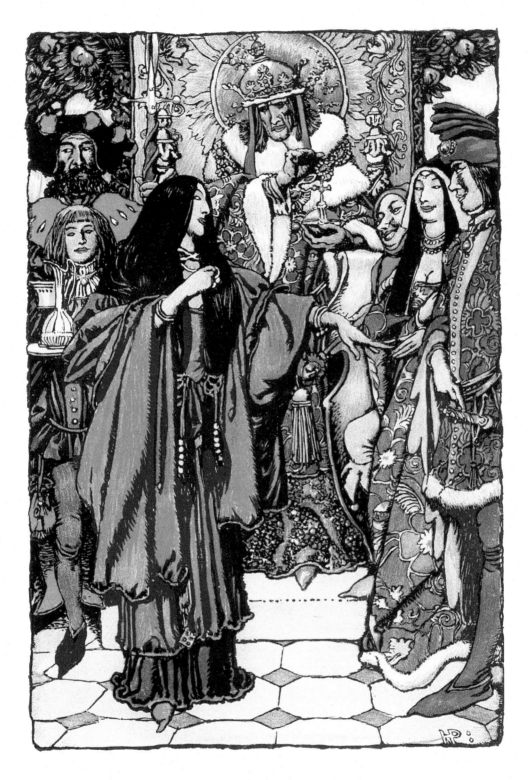

Truth Before the King
THE PILGRIMAGE OF TRUTH
Harper's New Monthly Magazine, December 1900

Plate 48

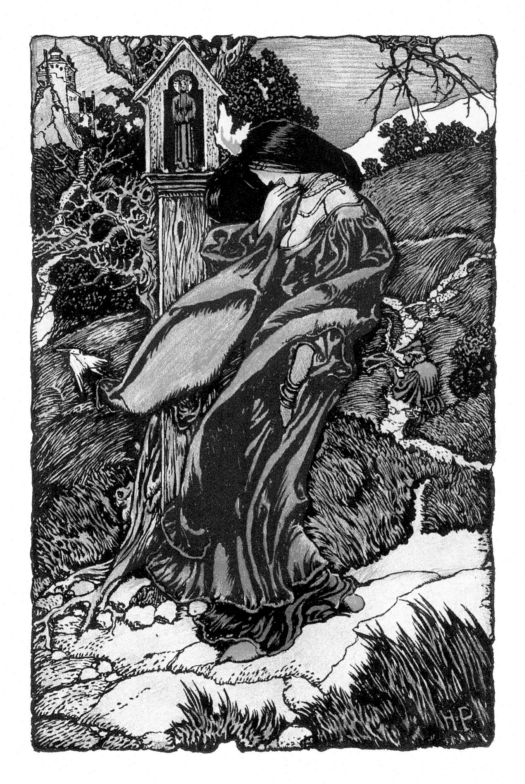

Truth Went on Her Way Alone
THE PILGRIMAGE OF TRUTH
Harper's New Monthly Magazine, December 1900

Plate 49

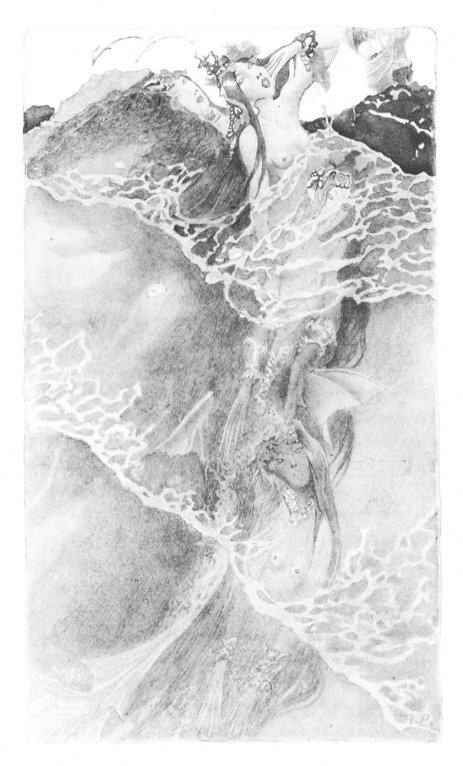

Frontispiece
NORTH FOLK LEGENDS OF THE SEA
Harper's Monthly, January 1902

Plate 50

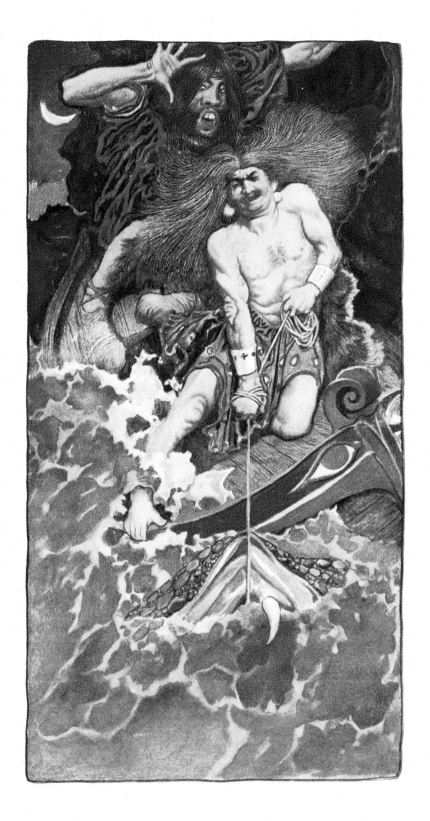

The Fishing of Thor and Hymir
NORTH FOLK LEGENDS OF THE SEA
Harper's Monthly, January 1902

Plate 51

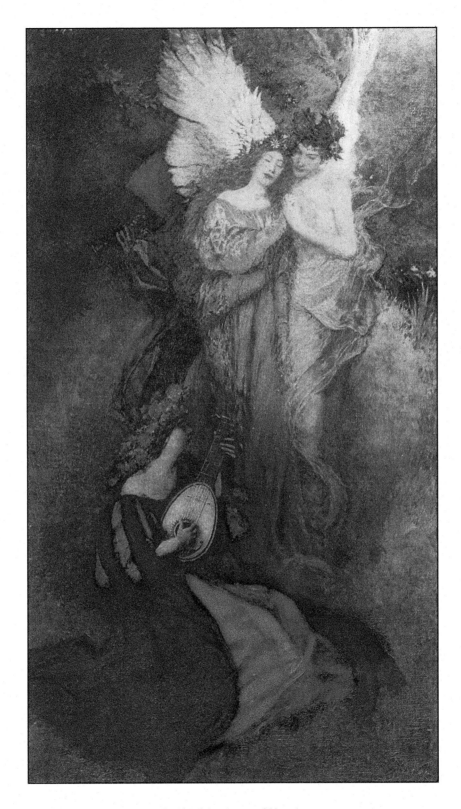

In the Meadows of Youth
THE TRAVELS OF THE SOUL
Century Magazine, December 1902

Plate 52

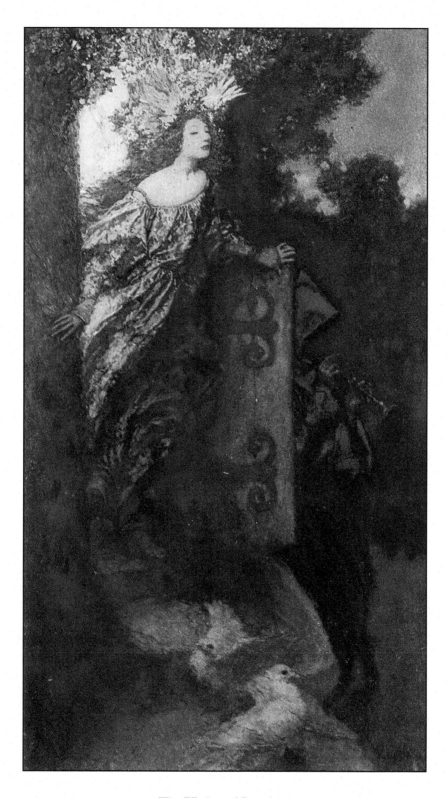

The Wicket of Paradise
THE TRAVELS OF THE SOUL
Century Magazine, December 1902

Plate 53

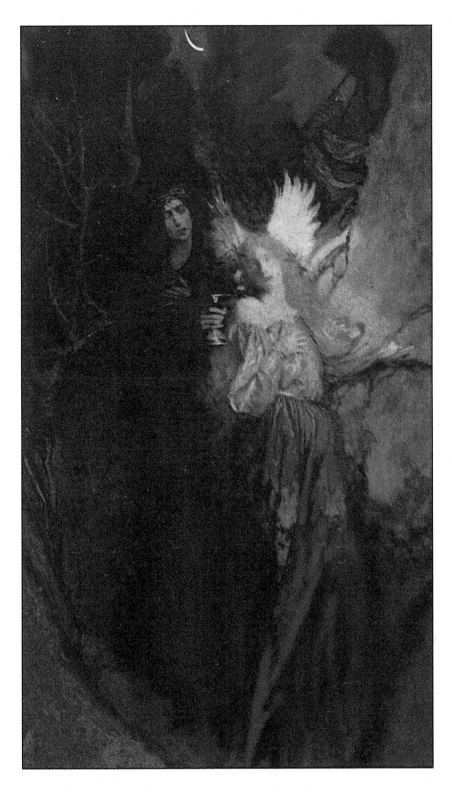

In the Valley of the Shadows
THE TRAVELS OF THE SOUL
Century Magazine, December 1902

Plate 54

At the Gates of Life
THE TRAVELS OF THE SOUL
Century Magazine, December 1902

Plate 55

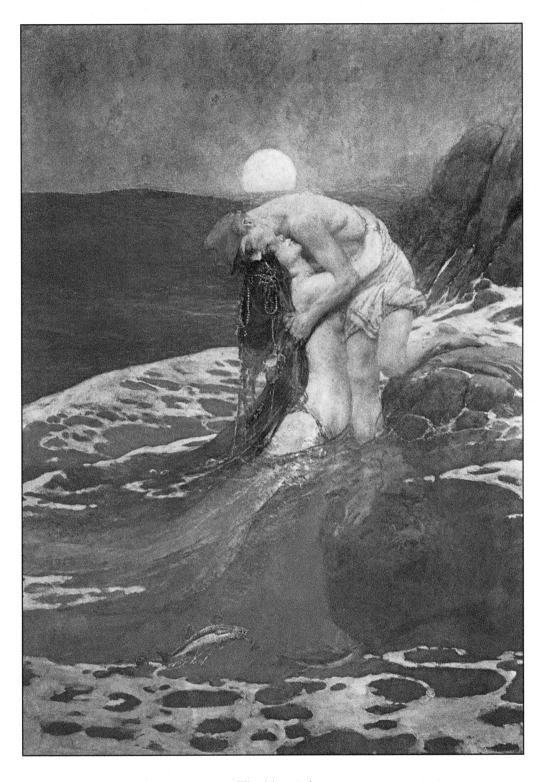

The Mermaid
Left unfinished, completed by Frank Schoonover
1910

Plate 56

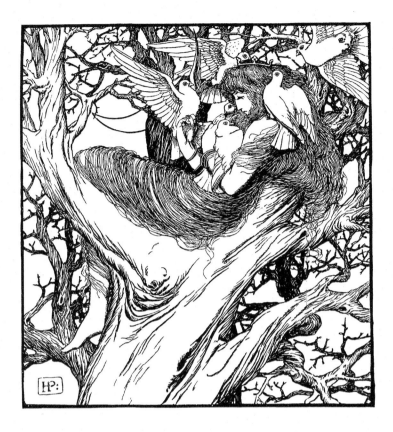

Princesses

The women Pyle painted—the handmaiden, the Savior of France, a fair courtesan, and an occasional mermaid—often warranted treatment as subjects by themselves, though the male characters were typically responsible for the advancement of the story line. Nevertheless, Pyle's princesses, for rich or poor, were held in high esteem and treated with respect.

Sometimes these princesses were pictured alone, like Branwyn soaking in the sun in Plate 64, or shown with a pursuer, as seen in the depiction of Clive and Ethyl Newcome in Plate 57. Whatever the context, Pyle's portrayal of young women was most often simple and direct, yet always retained a radiant quality.

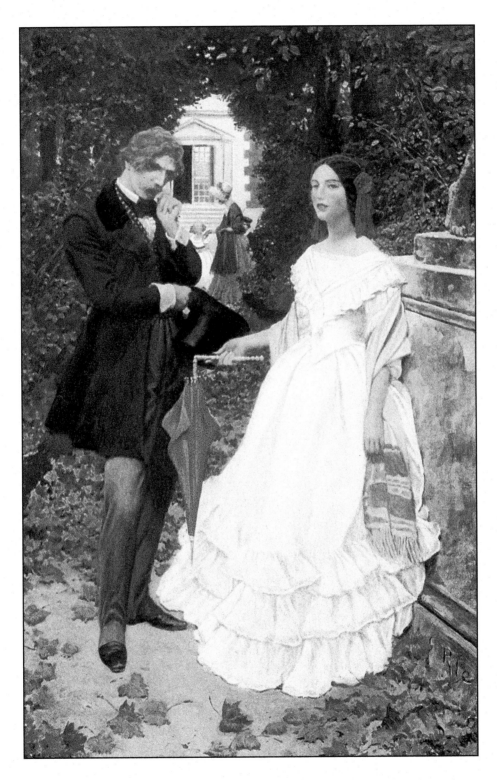

Pictures from Thackeray–The Newcomes
Clive and Ethyl Newcome
Scribner's, March 1897

Plate 57

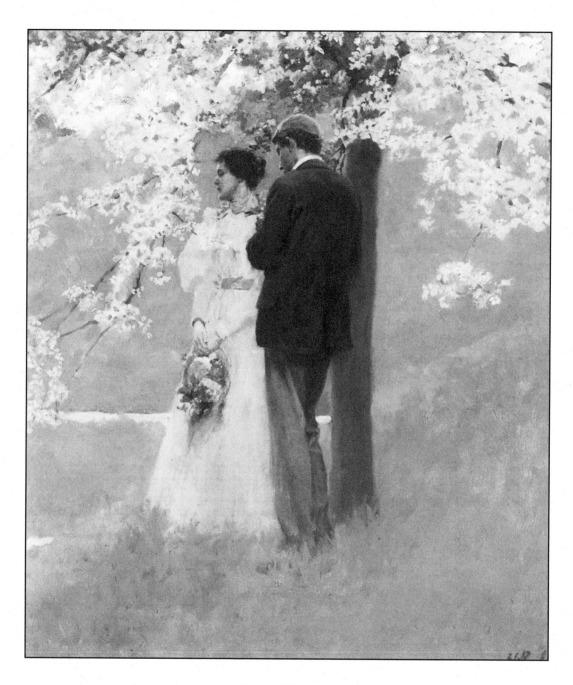

Spirit of Spring
a.k.a. Courtship
Ladies' Home Journal, May 1897

Plate 58

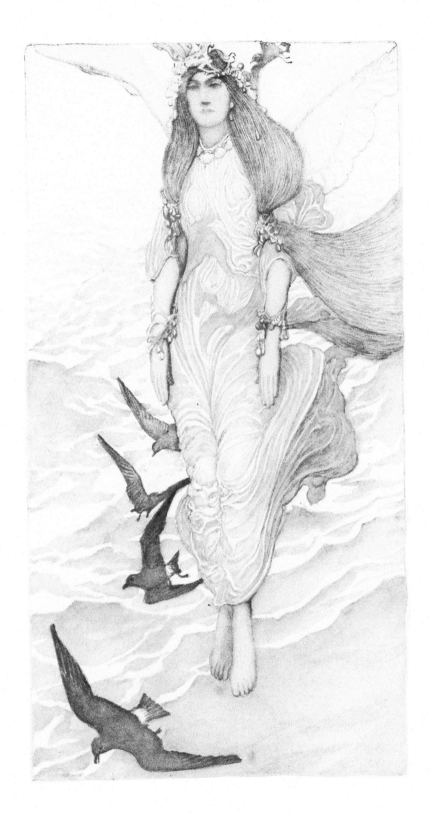

Mother Carey
NORTH FOLK LEGENDS OF THE SEA
Harper's Monthly, January 1902

Plate 59

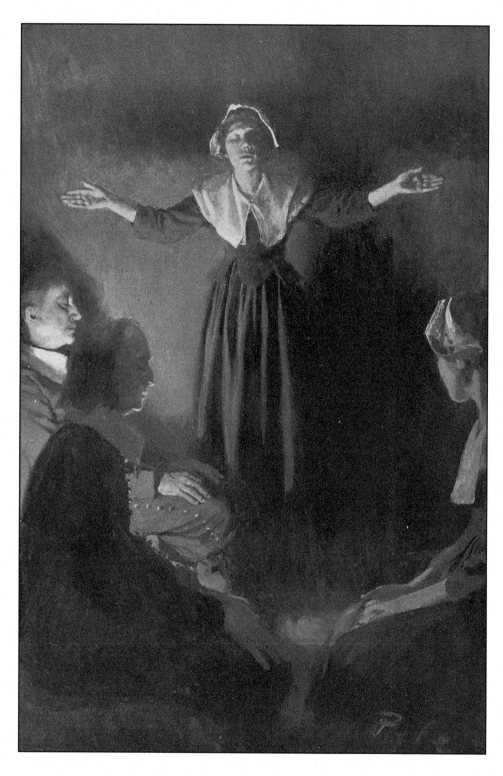

"I Have Been Reserved for This—to Free the Land from Spiritual Tyranny"
THE HANGING OF MARY DYER
McClure's Magazine, November 1906

Plate 60

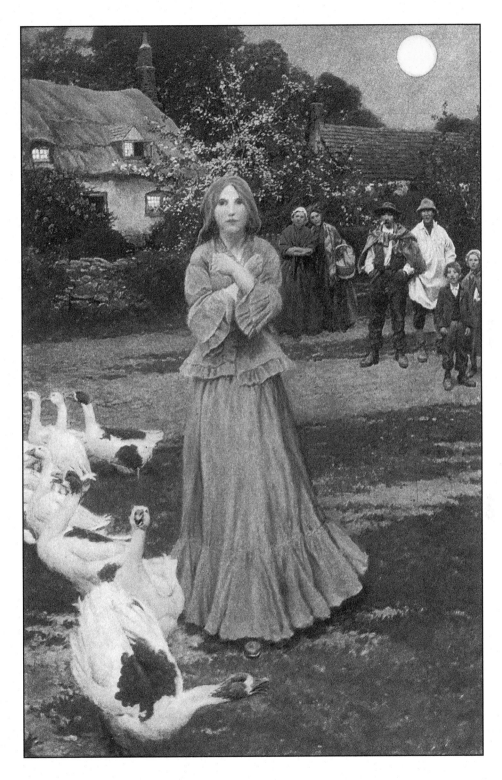

A Figure to Provoke Tears
A SENSE OF SCARLET
Harper's Monthly, February 1907

Plate 61

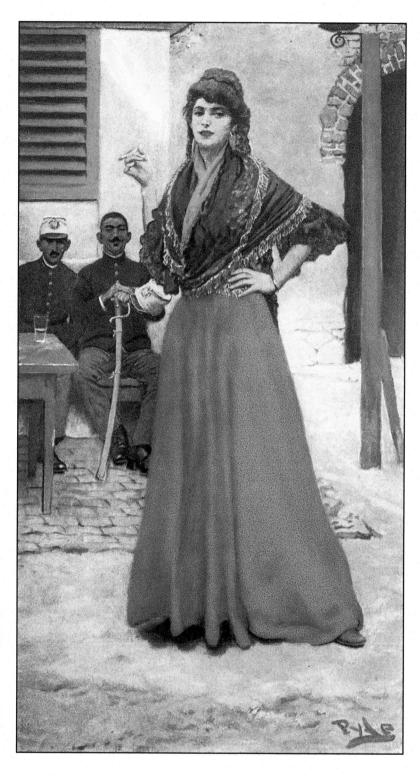

The Officers Would Be Waiting Until She Should Appear
DOÑA VICTORIA
Harper's Monthly, February 1908

Plate 62

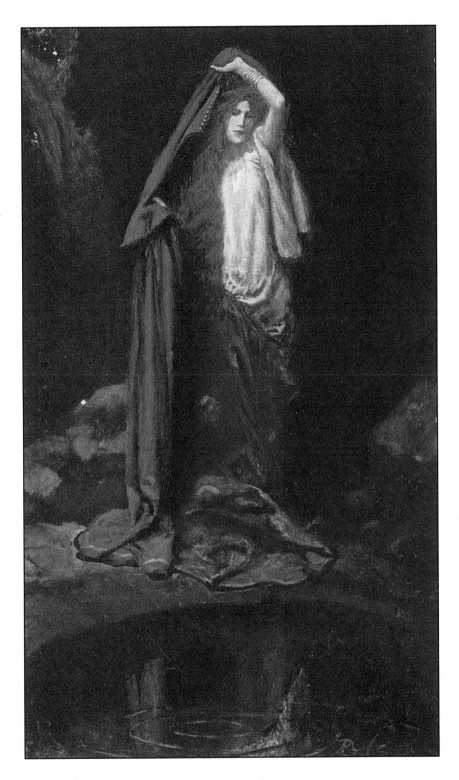

She Arrayed Herself in Silence
A PRINCESS OF KENT
Harper's Monthly, April 1908

Plate 63

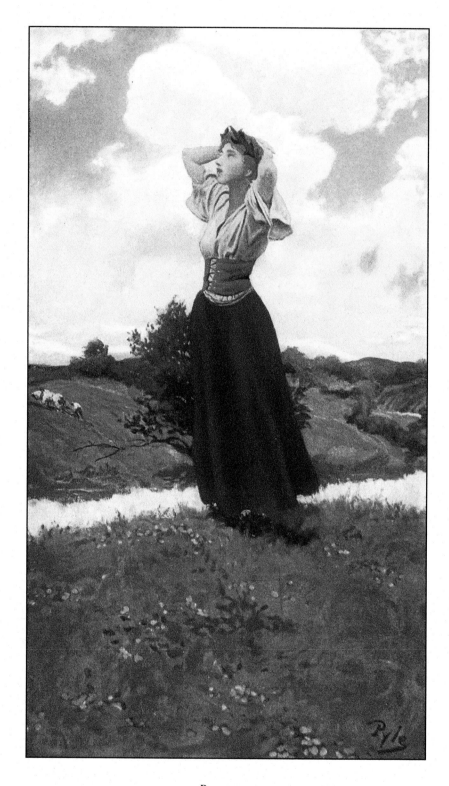

Branwyn
THE SCABBARD
Harper's Monthly, May 1908

Plate 64

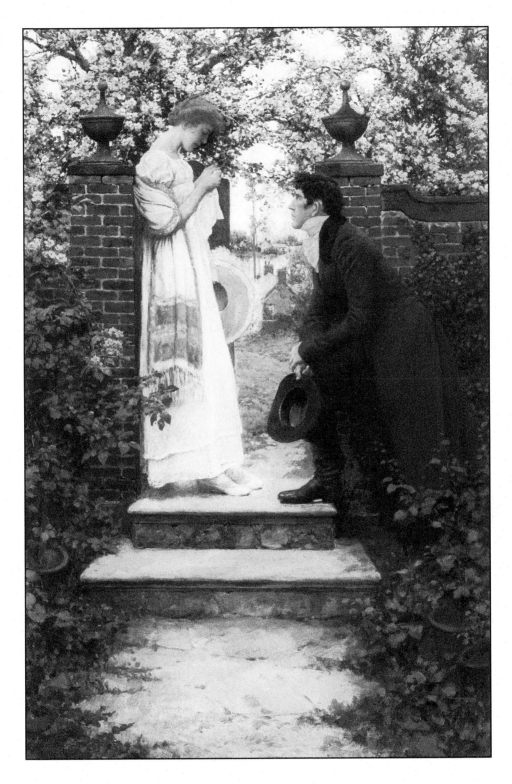

When All the World Was Young
WHEN ALL THE WORLD WAS YOUNG
Harper's Magazine, August 1909

Plate 65

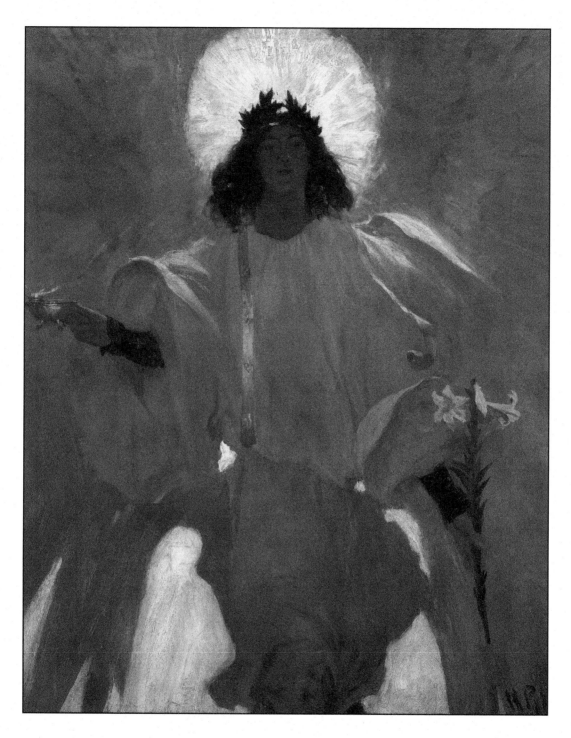

"Why Seek Ye the Living
Among the Dead?"
Collier's Weekly, April 15, 1905

Plate 66